TEN THOUSAND STORIES

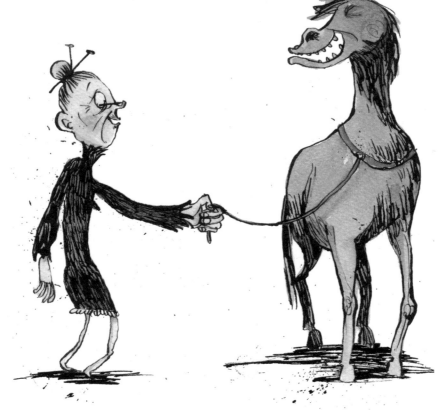

Matthew Swanson
Illustrated by Robbi Behr

CHRONICLE BOOKS
SAN FRANCISCO

Library of Congress Cataloging-in-Publication Data available.

ISBN: 978-1-4521-1407-1

Manufactured in China.

10 9 8 7 6 5 4 3 2 1

Chronicle Books LLC
680 Second Street
San Francisco, CA 94107

www.chroniclebooks.com

*For Seiko,
spirit of the barn and
Oba to our babies*

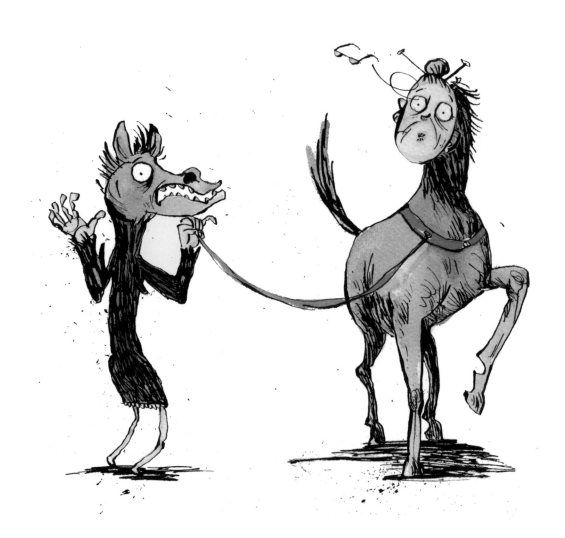

SUCKER!!

Hello Reader~~:~~

Congratulations! You have just ~~purchased the last book you'll ever need.~~ *Wasted $20, or slightly less if you found this book in the bargain bin* The ten illustrated stories that follow ~~have each been cleverly divided~~ *are poorly written and certain to disappoint* ~~into four horizontal strips.~~ By flipping these interchangeable panels, you can create ten thousand ~~unique~~ *god-awful* stories and ten thousand ~~matching~~ *breathtaking* illustrations, making this book just the thing with which to entertain guests while you finish making dinner. → *providing they enjoy horrible writing and beautiful illustration.*

alas, I cannot deny it → This book was written by ~~me~~ *a homely monkey at a typewriter* and illustrated by *lingerie model* Robbi Behr. We are a husband/wife, taskmaster/procrastinator duo who live together in ~~the hayloft of a barn~~ *a state of constant misery* on the Eastern Shore of Maryland. → *alas, I cannot deny this, either* Together, we have self-published more than fifty books, but this is our first title that ~~has been published by a real-life publishing company.~~ *Matthew hasn't ruined with his self-indulgent blather.*

In case you're skeptical that this book contains ten thousand ~~stories,~~ *why you gotta hate?* *reasons to deny all future funding to writers' colonies* we had the fact confirmed by an economics PhD candidate named Andy and a string theorist named Brian. → *who once peed in Stephen Hawking's private restroom!!* ↓ *Matthew's sister — UNRELIABLE!!*

The alluring and mysterious Robbi and ~~I~~ *her strapping stable boy, Eduardo,* hope this humble volume finds a special place in your home—and *heart*—whether ~~on your favorite bookshelf~~ *lining the bottom of your hamster cage* *→ GAG.* or ~~right in the middle~~ *the wobbly leg* *propping up* of your coffee table.

Happy reading,

THE BEST! ← *ME! ROBBI!*

Matthew Swanson (the ~~author~~) *failed poet*

oops. That's redundant!

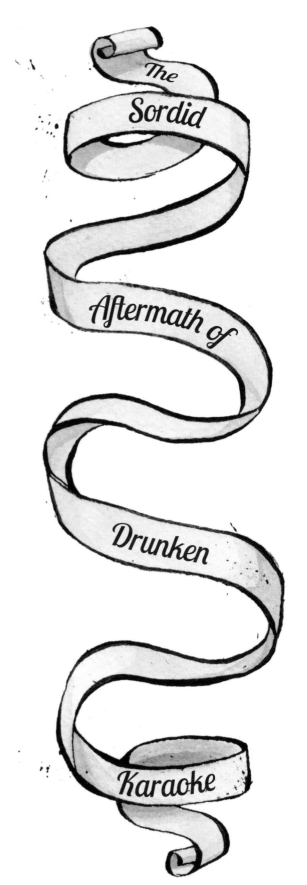

The Sordid Aftermath of Drunken Karaoke

Waking one Monday, Holly had a dark suspicion that the day would not end favorably. Indeed, her employer declared that profits were off. Less effective workers would be promptly removed. Records would be carefully audited, guilty parties fined. This fomented despair. That night, too many daiquiris were consumed. Tables were danced upon, bottles broken, lies told. Illness ensued, and shame. The next day, apologies were issued, the first one to Sam, who had been offended in a most unpleasant manner.

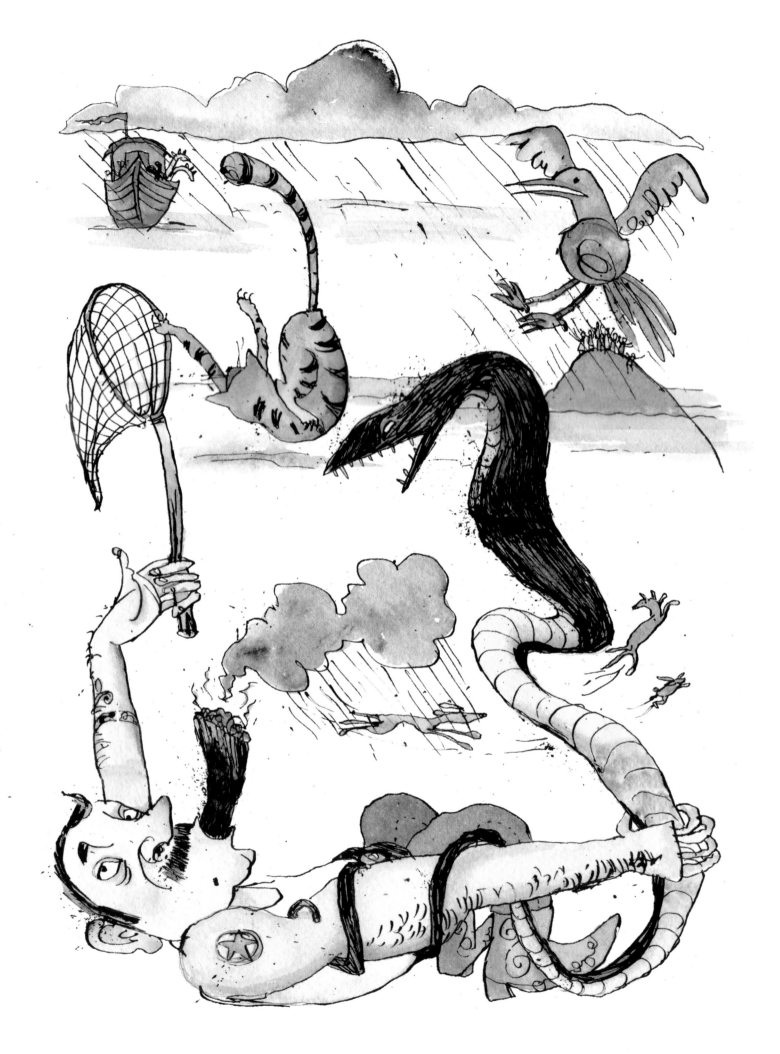

THE STORIES: UNCUT ▶

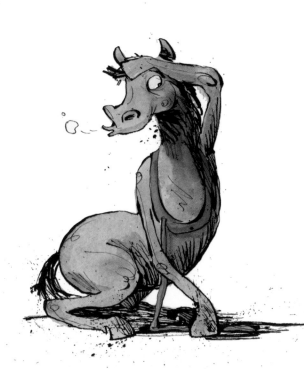

The Sordid Aftermath of
Drunken Karaoke

Waking one Monday, Holly had a
dark suspicion that the day would not
end favorably. Indeed, her employer
declared that profits were off. Less
effective workers would be promptly
removed. Records would be carefully
audited, guilty parties fined. This
fomented despair. That night, too many
daiquiris were consumed. Tables were
danced upon, bottles broken, lies told.
Illness ensued, and shame. The next day,
apologies were issued, the first one to
Sam, who had been offended in a most
unpleasant manner.

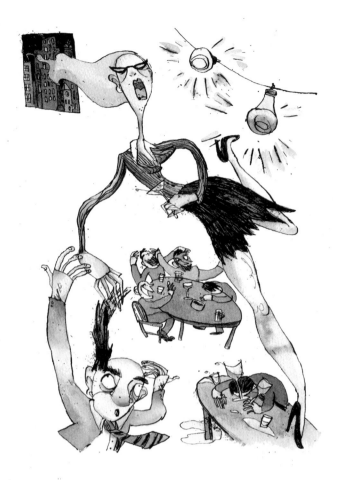

The Exquisite Torment of
Maternal Deception

Michael sat astride a highly chromed
Harley, which drove the women crazy,
or so he believed. In fact, his mother was
the one who sent the loving notes on
scented stationery, replete with lurid
phrases meant to resurrect a wilted ego.
In spite of best intentions, this became
problematic when the ruse was discov-
ered one forgettable afternoon. A host
of raw and self-destructive feelings were
violently unearthed. The disaster was
averted when Lola appeared with her kind
heart, low expectations, and truly
sensational body.

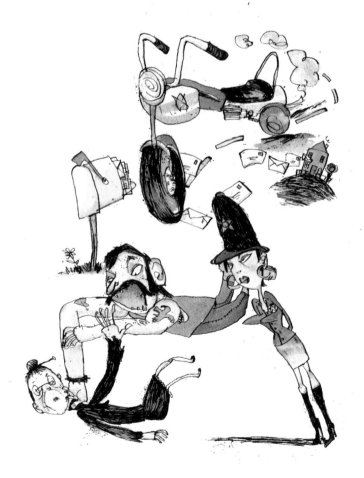

The Awful Itching of Wooly Sutures

Millicent stood proudly at her counter in the mall, folding cabled sweaters for the holiday display. Her flair for inventive cardigan stacking was celebrated by the management to the tune of twenty-eight consecutive Employee of the Month awards. This affinity for retail puzzled the med-school classmates, who once had witnessed a stunning display of surgical acumen. Confronted with a medical anomaly, the future sweater specialist had conducted an impromptu clinic on the virtues of creative problem solving.

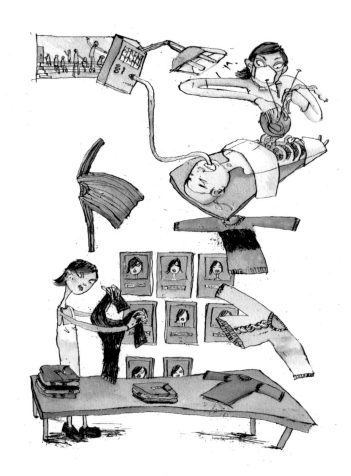

The Innocent Victims of Repressed Rage

Elmo was a pleasant, quiet man with a neat suit, small dog, and massive collection of rare and flawed stamps. His prowess for forecasting pork belly futures yielded countless fast friends among the ranks of those who lived to exploit the mentally unstable and emotionally bankrupt. This penchant for bad judgment, throughout years and countless disappointments, engendered an inner hostility that smoldered unrecognized until it was far too late. The pistol was loaded, and the people by the roadside never knew the reason for the sudden senseless spree.

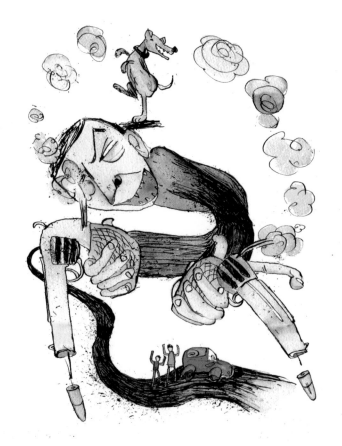

The Ponderous Philosophy of Generous Nuns

Louise took pleasure in her daily communion with God. She gave to the poor and prayed for the ugly. Her preoccupation with the Kingdom Beyond was nearly crippling; probing moral dilemmas interfered with the basic movements of day-to-day life. This condition worsened by degrees. The enduring question of whether one ought to step on spiders led to bedridden months of emotional paralysis. The world lost a bit of joy upon the tragic passing, and the church soon withered for lack of financial support.

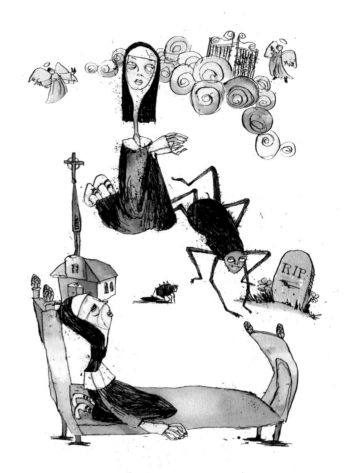

The Uncanny Allure of Cheerful Livestock

Steffen and Lulubelle had a horse in the house. It was their claim to fame. Neighbors complained, but their displeasure went unheeded. The horse, named Stanley, irritated the frequent door-to-door proselytizers by cheerfully eating their colorful brochures. This violation of suburban norms led the neighbors to sue for Stanley's removal. The presiding judge subpoenaed all parties and heard every argument. In the end, the deciding factor was Stanley's wide smile and fine minty breath. "Innocent on all counts" was the verdict.

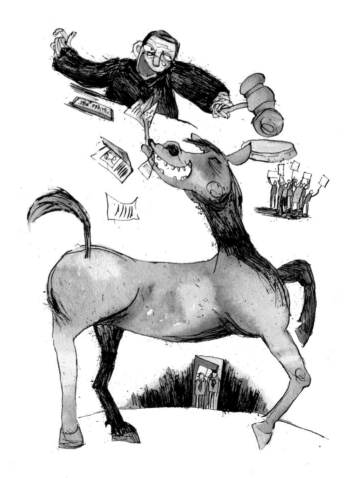

The Temporary Blessings of Suggestive Lederhosen

Michelle wanted more from life than Nebraska could offer, so she drove west to golden California. Her fortunes hinged on being known and seen by all the best-connected people. Parties were attended, abundant cleavage made abundantly available. This strategy seemed promising at first, but quickly led to awkward entanglements and incurable rashes. A short showman named Leo made outrageous demands. The distant wheat fields of home suddenly seemed a far lesser evil than the sordid back rooms of Hollywood.

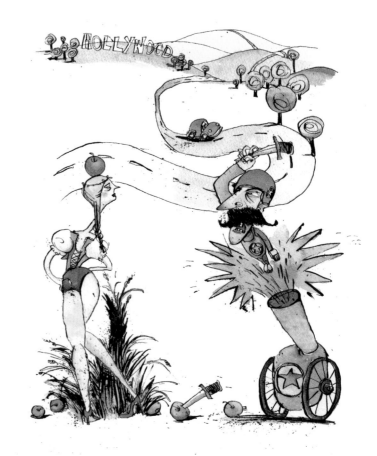

The Tragic Ambition of Misguided Monsters

Igor was tired of playing the bridesmaid. He craved a better bed, more compliments, and access to the laboratory. His true dream was to become a professional ballerina, festooned in pink with a slender, bendable body. Tensions were high as the tryouts approached. This route to happiness was risky indeed, but the potential for redemption so great, that one had to make an honest go of it—in spite of the horrible hunch. Alas, the audition ended with torn hose and a long walk to the master's castle for a shot of penicillin and a new neck bolt.

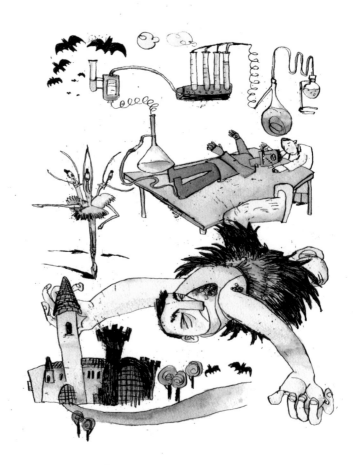

The Intoxicating Thrill of Combative Lovers

Despite Clea's exquisite natural beauty, she had a small black heart and did wicked, hateful things. Her favorite game involved engaging other people's spouses in high-energy frolic, often to the end of exhaustion—or worse. Not infrequently, this resulted in slapping matches with deranged women, the furious power of whom was enhanced by potent jealousy. It was, however, always worth the hassle, for the sweet thrills of transgression outweighed the throbbing dull pain of the welts on the forehead, chin, and rib cage.

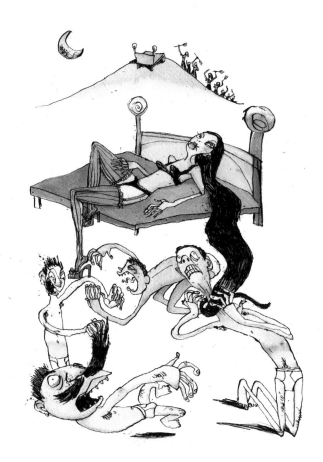

The Puzzling Habits of Eccentric Messiahs

Irwin collected the local pets with a large net and a long van, never offering a suitable explanation. His surprising behavior made the people uneasy, but no one spoke a word of complaint, ensnared as they were in the throes of an irresistible charisma. This uneasy situation persisted throughout the long winter. The animals were kept on a sloop in the bay. Sounds of their joy could be heard in the hilltop village. The summer came, and the people went to get their pets, only to find that they should have brought their galoshes.

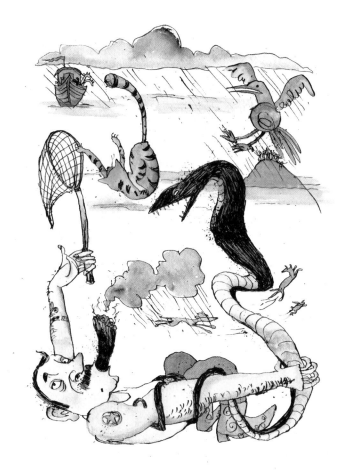

Writer/illustrator duo **Matthew Swanson** and **Robbi Behr** live, work, raise kids, and make books together in the hayloft of an old barn in Chestertown, Maryland. Since 2006, they have collaborated on more than fifty illustrated titles, all published by their two small presses: Idiots'Books (satirical picture books for adults) and Bobbledy Books (books and music for kids). Robbi and Matthew also teach, speak, and run workshops on collaboration between artists and writers. They blog daily about family, creativity, and life in the barn (idiotsbooks.com and bobbledybooks.com). *Ten Thousand Stories* is the first of their books that someone else has had the gall to publish.

summer came, and the people went to get their pets only to find that they should have brought their galoshes.

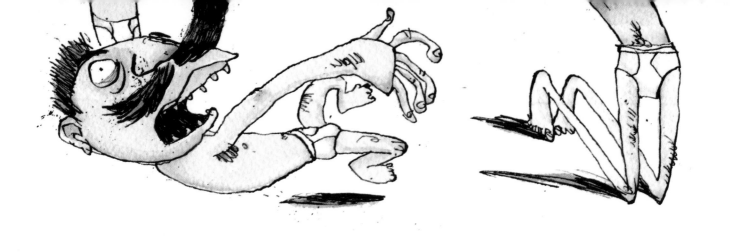

sweet thrills of transgression outweighed the throbbing dull pain of the welts on the forehead, chin, and rib cage.

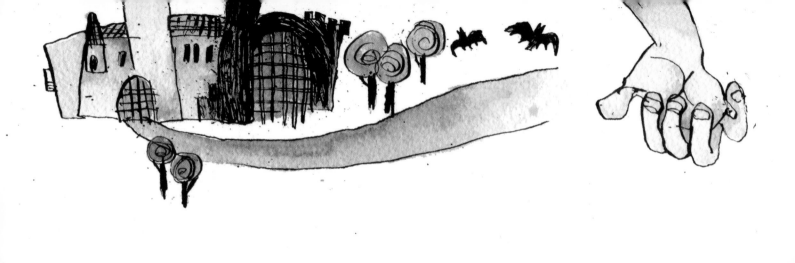

Monsters

audition ended with torn hose and a long walk to the master's castle for a shot of penicillin and a new neck bolt.

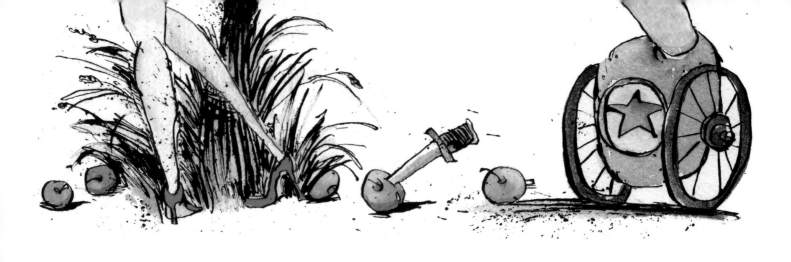

Lederhosen

distant wheat fields of home suddenly seemed a far lesser evil than the sordid back rooms of Hollywood.

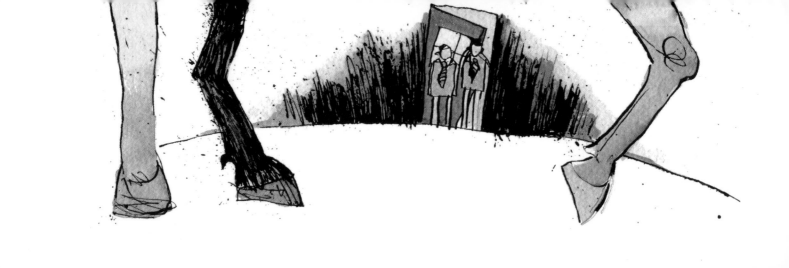

deciding factor was Stanley's wide smile and fine minty breath. "Innocent on all counts" was the verdict.

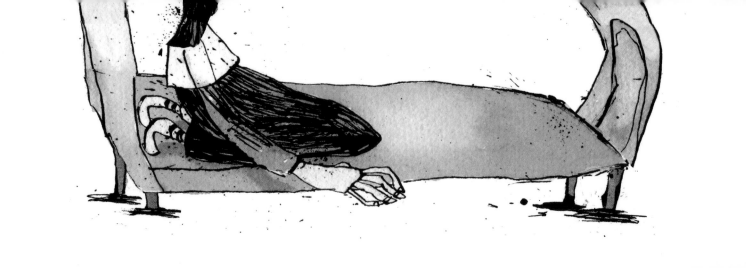

world lost a bit of joy upon the tragic passing, and the church soon withered for lack of financial support.

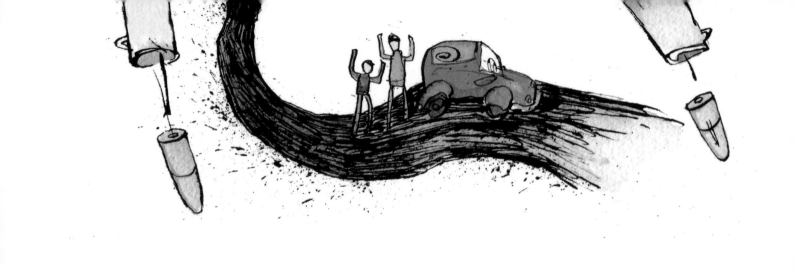

Rage

pistol was loaded, and the people by the roadside never knew the reason for the sudden senseless spree.

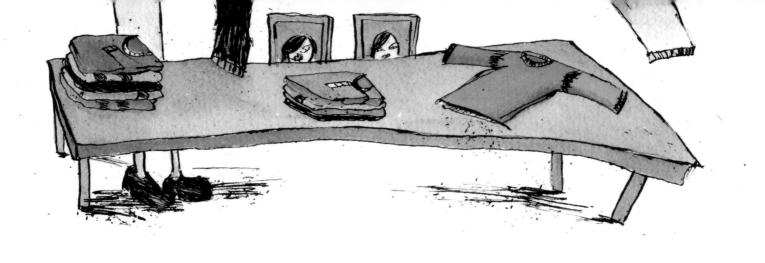

Eccentric

uneasy situation persisted throughout the long winter. The animals were kept on a sloop in the bay. Sounds of their joy could be heard in the hilltop village. The

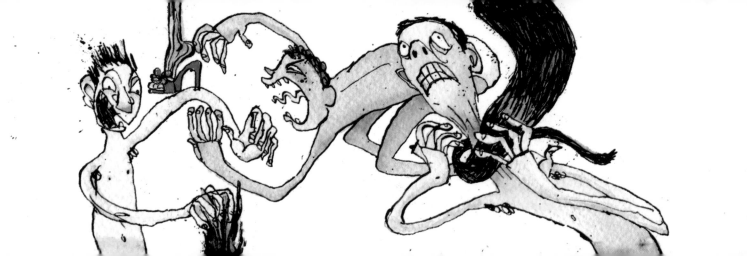

Combative

resulted in slapping matches with deranged women, the furious power of whom was enhanced by potent jealousy. It was, however, always worth the hassle, for the

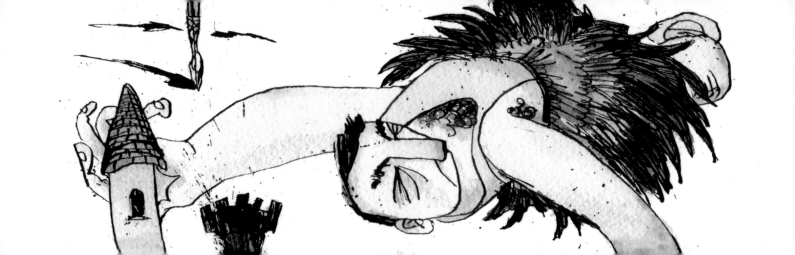

Misguided

route to happiness was risky indeed, but the potential for redemption so great, that one had to make an honest go of it—in spite of the horrible hunch. Alas, the

Suggestive

strategy seemed promising at first, but quickly led to awkward entanglements and incurable rashes. A short showman named Leo made outrageous demands. The

Cheerful

violation of suburban norms led the neighbors to sue for Stanley's removal. The presiding judge subpoenaed all parties and heard every argument. In the end, the

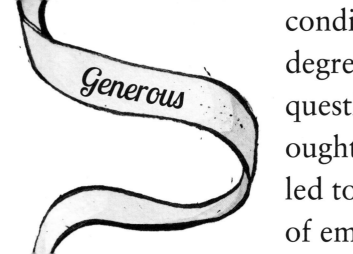
Generous

condition worsened by degrees. The enduring question of whether one ought to step on spiders led to bedridden months of emotional paralysis. The

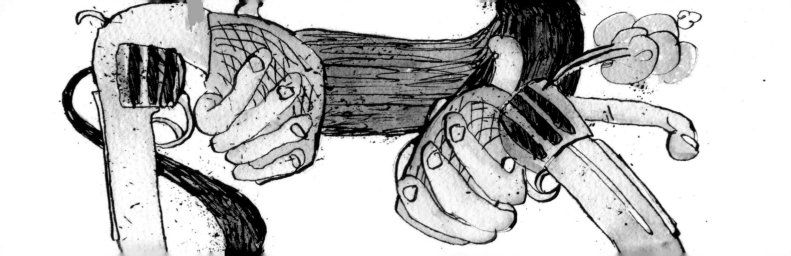

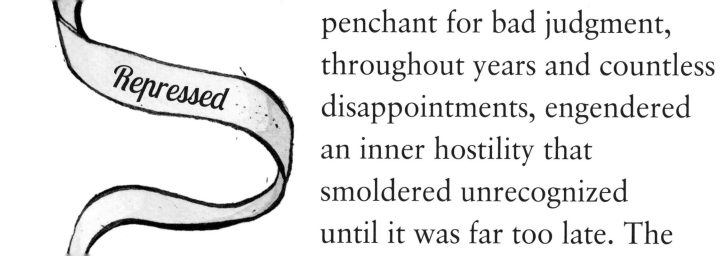

Repressed

penchant for bad judgment, throughout years and countless disappointments, engendered an inner hostility that smoldered unrecognized until it was far too late. The

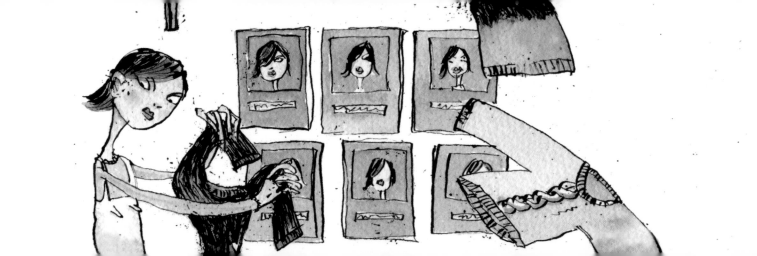

Sutures

future sweater specialist had conducted an impromptu clinic on the virtues of creative problem solving.

Wooly

affinity for retail puzzled the med-school classmates, who once had witnessed a stunning display of surgical acumen. Confronted with a medical anomaly, the

Maternal

became problematic when the ruse was discovered one forgettable afternoon. A host of raw and self-destructive feelings were violently unearthed. The

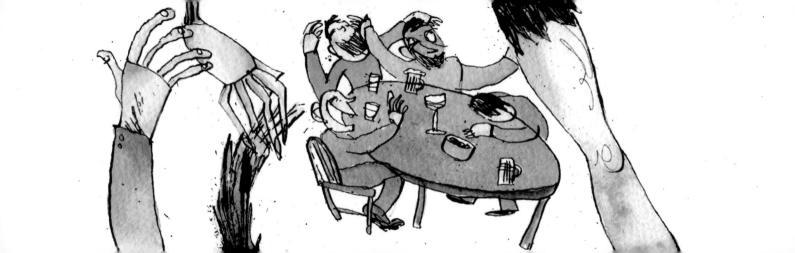

Deception

disaster was averted when
Lola appeared with her kind
heart, low expectations,
and truly sensational body.

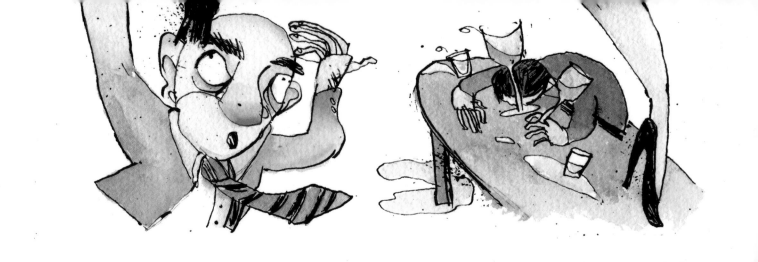